DISCARD

HOMETOWN, TEXAS

Other books by karla k. morton

Wee Cowrin' Timorous Beastie - Lagniappe Publishing

Becoming Superman - Zone Press

Redefining Beauty - Dos Gatos Press

karla k. morton: New and Selected Poems - TCU Press

Stirring Goldfish - Finishing Line Press

Names We've Never Known - Texas Review Press

No End of Vision - Ink Brush Press (with Texas Poet Laureate Alan Birkelbach)

8 Voices: Contemporary Poetry from the American Southwest -
Baskerville Publishers (Anthology with seven other poets)

Passion, Art, Community: Denton, Texas, in Word and Image -
The City of Denton, Texas

YOUNG POETS & ARTISTS CELEBRATE THEIR ROOTS
HOMETOWN, TEXAS

KARLA K. MORTON

TCU PRESS

FORT WORTH, TEXAS

Library of Congress Cataloging-in-Publication Data

Hometown, Texas : young poets and artists celebrate their roots / [edited by]
Karla K. Morton.
 p. cm.
 "In her role as 2010 Texas State Poet Laureate, Karla K. Morton created a Little
Town, Texas Tour to serve as an ambassador of poetry. The tour's main mission
was to bring poetry to teens across Texas, making poetry more accessible and
relevant to students, especially in towns that may be underserved in the arts.
Along the way, Ms. Morton also spoke at various cancer centers, fundraising
events and support groups, where she shared from Redefining Beauty, a poetry
collection she wrote during her own diagnosis, treatment and survival of breast
cancer."--Karla K. Morton web site; Projects; Little Town, Texas Tour; viewed
Oct. 3, 2012.
 ISBN 978-0-87565-544-4
1. High school students' writings, American--Texas. 2. American poetry--21st
century. 3. American poetry--Texas. I. Morton, Karla K.
 PS591.H54L58 2013
 810.8'09283--dc23
 2012038943

TCU Press
PO Box 298300
Fort Worth, Texas 76129
817.257.7822
www.prs.tcu.edu

To order books call 1.800.826.8911

Designed by fusion29.com

To the great state of Texas,
and all her people—old and young,
in every village, town, and city,
who will forever call her *home*.

Acknowledgments

Leaving Brenham Langdon Review of the Arts

Love Song in Bertram Southwestern American Literature

Owls Visual Artists Collaborative

Calling the Cattle Denton Poetry Anthology

New Sheets CCC Forces Literary Journal

Preface

The poet e.e. cummings wrote: *It takes courage to grow up and become who you really are.*

And I would add that it takes a dream. This book is an attempt to help fulfill the artistic and literary dreams of Texas school-children who might not normally have had the opportunity. This book is a gift—not only to them, but to the cultural richness and diversity of the state.

This book actually began to take shape when I was in the eighth grade. I had the same type of literary dream.

You see, in the eighth grade, we talked about the position of Texas Poet Laureate in school, and I remember running home and saying, "Mom, I want to be Texas Poet Laureate!"

Mom said, "That's nice dear. . . . What is that?" But from that day on, it was in the back of my mind. I wrote *all* the time, and studied journalism at Texas A&M University. I pursued that dream of poetry as my passion.

On May 19, 2009, I received a phone call from the Texas Commission on the Arts telling me I had been named the 2010 Texas Poet Laureate. I couldn't believe it. I think I screamed into the phone. I had to pull off to the side of I-35, between Denton and Dallas, get out of my truck, and do the crazy-girl dance right there, in rush hour, on the side of the road. Traffic was speeding by, honking and waving, but I didn't care—I was thinking, "Woohoo! How crazy and unbelievable is this? I am the Texas Poet Laureate—a dream come true!"

As is true of so many dreams—when it came true for me, my world opened up. I had battled cancer the year before—and that nightmare actually began on that *very same day, a year earlier*—May 19. What had been the worst anniversary day of my life suddenly became the best day of my life. Dreams can transform. I knew I had been given one of the greatest gifts ever. It was as if God was saying *We are just getting started, baby! This is your new life!*

I had wanted that title for so long, so I thought—what can I do to give back? And I remembered being that girl in the eighth grade, and I remembered the dream that felt too big to even wish for, and I wanted to tell other eighth graders—heck, *any* school-child—that their artistic dreams could come true, so I put together this idea of a "Little Town, Texas" tour—traveling to as many towns as I could during my first years as laureate.

In Texas, there is no funding for any Texas Poet Laureate. The first Texas Poet Laureate was appointed in 1932, and it has always been an honorary title. There is no stipend, prize money, travel expense, crown or tiara. And, generally, the laureates are given the title for one year. On the other hand, once you are appointed a laureate you are *always* considered a laureate—just not the current laureate. Yes, a laureate is named every year, but we are all laureates for life. Okay, that's a good trade! Retaining the title gave me the extra opportunity, and time, to help plan the "Little Town" tour. The challenge in all this was, and still is, funding—for each laureate. Grateful acknowledgment goes to my husband for letting me drain the savings account. Businesses and organizations are reluctant sponsors for artistic and literary endeavors, especially at such a grassroots level. Unfortunately, poets laureate are not sports teams or racecars. It is a practical consideration—and a sad thing. But it is also part of the message that I try to convey to all the students—don't let financial issues or remoteness or environment keep you from pursuing your dreams. Poetry is essential to life. It is one of my goals to bring poetry into the spotlight; to show it is vibrant and accessible and exciting and fun—and oh so important!

Other than the funding, the hardest

part of this tour was getting the word out to towns across Texas. When they heard, the response was enthusiastic. They opened their homes and schools and community centers and libraries. I went to speak to the kids and adults and teachers, shared my story, and told them that I truly believe there is something great inside each and every one of us, and half the fun of school and college and life is figuring out what your gift is—and then giving it back to the world.

The December before I was named laureate, my husband had given me a great gift—custom boots from M. L. Leddy's in Fort Worth. When I let them know I was laureate, Leddy's put me at the top of the queue, put me with their master bootmaker, and added a Texas star surrounded by a laurel wreath to honor the title. Those boots became my companions—and my symbol. Those boots were (and still are) a material thing, something kids could see, a way to measure success and accomplishment, something they could physically work and wish for.

Over eighty thousand miles my boots and I traveled, many times to places I had never been, but each town, each community I went to made me fall in love with Texas all over again. This state and her people are diverse, eclectic, creative, and kind.

The tour began at Mansfield High School, my alma mater. It seemed a perfect fit to go back to the place that helped me become who I am. I spoke with the students, weaving in poetry from my book *Becoming Superman*. Other schools wanted workshops. Some schools had me in English classes. Some schools let me speak to the entire student body in the auditorium. Some schools held community events and readings. I let each community decide how I could best serve them, but the message was always the same, and I had one request: that they have a poetry and art contest with their town as the theme.

I wrote a poem about each place, then gathered the kids' artwork and poems and put them together here. I thank TCU Press for publishing this amazing, one-of-a-kind book. Anyone who publishes poetry in this day and age is doing it out of love—love for the written word, love for literacy and the arts, and in this case, love for the kids of the great state of Texas.

Poetry belongs to every man, woman, and child. All you need is paper and pen. Poetry is words from one heart that reach into another heart. Poetry moves us; it is the link between mankind and God. This is why in times of happiness or sadness, grief or great love, we reach for poetry. It tells us we are not alone in this world—we are all connected through our emotions.

To all the students, teachers, schools, and communities, I thank you. Thank you for your participation; for your inspiration; for making this happen.

In this age of digital emptiness, this age of plastic, it's good to have the anchor of a book, especially a book of poetry and art, to help us go forward in our lives; to help us remember that true strength comes from the *inside*. Quiet times of reading and introspection fortify us to go into the world, give our gifts, and make our lives count—every day, every moment.

Like cummings said: it does take courage to grow up and become who we really are. I am a poet. And there are lots of other amazing young poets and artists across the state of Texas. I know. I've met them. Many of them are in this book. Maybe you are a young poet or artist yourself. Here is my message to you, to all of you:

Pick up you pens, your pencils. Create.
Be brave enough to dream your
 greatest dream.

k.k.m.

MANSFIELD, TEXAS

Small Town

Summertime

Nightfall Remembered

Population 1,088

Field Trip

Small Town

There is nothing bad about a small town,
especially when your neighbor is farmer Brown.
Even though his cows disappear and we don't know why
And bright lights cross the dark night's sky.
Brown's thumb is green, but his crops never succeed,
But not because of an overgrown weed.
His crops are always covered in rings
He also likes to lie about things:
About how his car floats and his skin is pale.
The police came and he is gone. Now his farm is for sale.

Carrie Gibson
Mansfield High School

Small Town by Carrie Gibson
Mansfield High School

Summertime

Small Town

Red's Café, Bella's Beauty Shop

Small Town

Mizz Rosa's Roses, Ray's BBQ

Small Town

Living Word Community Church on Savior Drive,

Salvation Army on Helping Hands Corner

Small Town

Mizz Thelma's Porch

Small Town

Mistah Rudy's Yard

Small Town

Good food, Good times, Good fun, Good people

Summertime

MY Small Town

Nakia Williams
Mansfield High School

Summertime by Nakia Williams
Mansfield High School

Nightfall Remembered

What was the name? I say as
I wait on the steps of the charming little porch whilst
the crickets sing low beneath the
swarthy old oak whose branches
sway with a dancer's grace to
the tune of Nature's everlasting chorus and
Life's gently beating drum: a testament
to the day's close by Twilight's golden curtain.
The town beyond glistens
with the sweat of labor in the Sun's
final rays as neighbors
fly from their roosts beside
windows in wait for the return
of Dawn and the gathering of
juicy gossip
from ripe vines of lips and tongue.
As they crawl softly into bed and
snuff out their lights, darkness ensues and the
Ancient metropolis of the Heavens
shimmers above in a picturesque
manner of glittering skyscrapers and
mysterious, swirling purple galaxies;
silver clouds glide by
to greet even this, the
smallest of towns as comets
create a cadenced pulse to
guide this sweet symphony.
And as I sit, listening to
this serene atmosphere that
flourishes in the country air,
a revelation comes like
Dawn to the Day; this
song that plays in my head came from
a little town that sleeps
within my memory . . .
Dawson.

Madison Samas
Mansfield High School

Nightfall Remembered by Madison Samas
Mansfield High School

Population 1,088

The summer breathes life,
The sleepy porches,
A refuge from the heat,
The bustle of the morning.
A pickup breaks the silence,
A friendly nod and wave.
Old-timers drinking coffee
Around the cotton gin and co-op,
History is reborn.
Sneakers crunch the gravel,
Trek to the Duckwalls,
A highlight of the morning.
So quiet, thoughts blossom.
No question arises to who you are at that moment.
God's plan,
So evident,
Be happy and live.
No hustle
No bustle
No distractions.
Tears now roll,
Remember those summers,
That house, the smell of dirt,
Bliss,
Never forget
A small town,
Population 1,088.

Emilie K. Thomason
Mansfield High School

Field Trip

I don't remember the field trip—
our great educational adventure;

but what I *do* remember
is the bus breaking down

in Fort Worth, by the Ranch
Style Beans building;

making every gastrointestinal joke
we could think of, then rolling down

that hill, one after another, like
squealing logs, our hair, snagging

May grasses and roadside scrub,
until the replacement bus came.

And the next day, in class,
the teacher's frustration at twenty-five squirming,

agitated bodies, full of chiggers.
I covered each tiny red mound

in clear fingernail polish—sealing their tombs
as they sank to the bottom of my epidermis

like doomed submarines. Weeks later,
comparing wounds like old soldiers,

we'd think about that day of freedom,
when time was all we had;

when we gave our bodies to gravity—
to the wild, orbiting ride of the Earth.

karla k. morton

BONHAM, TEXAS

Several Yesterdays Ago

Bonham

Wildflowers, March 6, 1836

Bonham Boots

Several Yesterdays Ago

One Sunday morning I was sitting at the counter of a local restaurant. I noticed three African American mothers with their small children, sitting at three different tables. Their appearances and mannerisms were a compliment to their race. It was custom that when the checks were paid each child received a sucker. I noticed this one little girl with neatly braided pigtails and bright pink dress. I'd say she was about four and a quarter years of age, and cute as a button. She was excited, awaiting her sucker. They left, I assumed off to church. About fifteen minutes later, this same precious little girl came and sat down bedside me. Evidently her mother didn't know she was missing. As we talked and giving her unwrapped sucker much attention, I asked her, could I have a bite of her sucker? Without hesitation she gave the sucker to me. Fighting back the tears within me, I gave the sucker back to the little girl and said this is yours. Again, this was several yesterdays ago.

Oft times, I color a portrait in my mind of that little African American girl, and the lesson she gave me in the way of giving. Each time I'm reminded of the Lord telling his disciples, suffer little children, and forbid not, to come unto me, for of such is the kingdom of heaven.

Jerry Sandefur
War Veteran, VA Hospital

Bonham by Alexis Orsak
Bonham High School

Wildflowers, March 6, 1836

When he heard Travis needed him,
James Bonham dropped his law books,
tossed rations in his saddlebags,
rode hard to Texas.

How could he have noticed the gentle
green on the ground, the tender leaves
curling out . . .

He was already a Texan before crossing
that border—leaving everything behind
to help a friend and a fledgling Republic;
knowing few would fight against the many.

But he came anyway, thin shoots at his feet
reaching up into buds, refusing to cross over
that line drawn in the dirt.

And in his last breath, as limestone walls cradled
him in their arched shadows, that same earth
rose sweet against his cheek . . .

Looking down, Santa Anna sneered in his victory,
never noticing his horse had reared up—away
from the land, as bluebonnets and orange paints
burst to claim their own.

karla k. morton

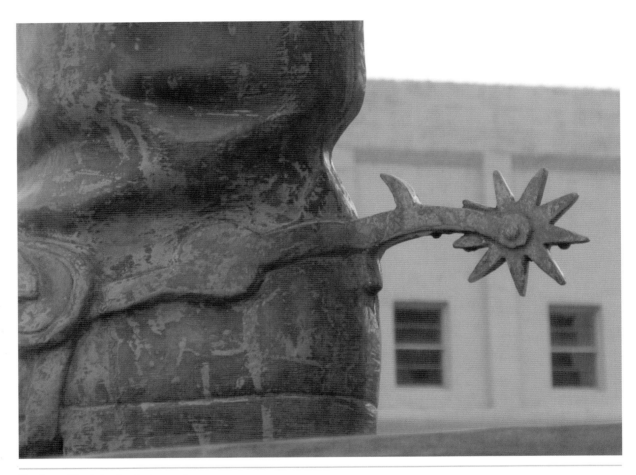

Bonham Boots by karla k. morton

KYLE, TEXAS

Kyle City Hall

From Water Towers to Railroads

The Tree Next to the Hanging Tree

Kyle City Hall by Brenna L. Veloz
Wallace Middle School

From Water Towers to Railroads

From water towers to railroads
And creeks to rivers
Our town, my town,
The City of Kyle.
Where Indian paintbrushes and
Bluebonnets are as far as the
Eye can see
Co-mingling our multi-cultural city
Where our friends are your friends.
Stop for a visit, enjoy our town
Where an idea led to a home.

Alyssa Oineon
Wallace Middle School

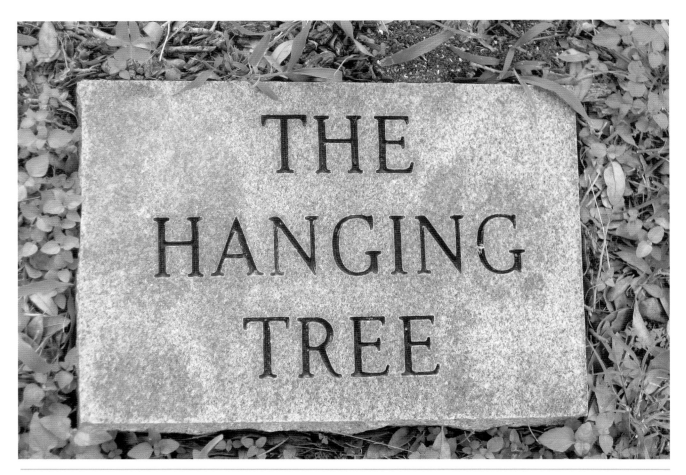

Hanging Tree Marker by karla k. morton

The hanging tree in Kyle, Texas, is in the cemetery on Old Stagecoach Road. Legend has it people found a stranger hanging, cut him down, and buried him right there, which was the beginning of the Kyle Cemetery.

The Tree Next to the Hanging Tree

All the trees but one shut their eyes
that night in 1879,
having never grown used to such human
brutality, only opening their arbor lids at dawn,
squinting at the sun's glare on dangling spurs,
four feet off the ground.

––––––––––––

karla k. morton

BRENHAM, TEXAS

Pelican

Butterfly

Leaving Brenham

Cow

Pelican by Claire Reue
Brenham Junior High School

Butterfly

This poem was written by an eighth grade student during a class study of the Holocaust. In Theresienstadt, a Nazi concentration camp near Prague, Jewish children wrote poems and essays and drew pictures as a way of handling their situation and their feelings. After the war, these drawings and poems were found, and some were published in a book entitled I Never Saw Another Butterfly, after a poem by the same name. This poem is in response to those children, their poems, and their tragic fate.

What is love? Hope? Freedom?

Hell did not have these. All that I loved was gone.

The suffering was unbearable. Animals in cages are what we were.
Death was our fate, our cruel fate.

But lo, a flittering angel visits. I have never seen anything so graceful.
It is free, with no cares. Its stunning beauty and elegance capture me.

I watched as it floated. Away. So long, my friend.

I cannot miss you because this place has no emotions. No smiles or tears.
Goodbye, my sweet and everlasting butterfly. I followed its trail with my
burning eyes.

Why must I be cursed because of my beliefs? Why must I be punished
because of my beliefs? Why must these demons hurt us so?

The butterfly flew by Block 11 as my mother and sister were shoved inside.
This was the last time I ever saw them. Alive.

The crematory soon burst with fire. It took my mother and sister with it.

Curse you, butterfly!

Oh, but I cannot. It is too kind to do that.

I waited, wishing my tortures would cease. They did.
With the crematories flaming.

Goodbye, my sweet and everlasting butterfly.

Callie Stegemeier
Brenham Junior High School

Leaving Brenham

What is the word for love of the road?
I am neither hitchhiker, nor trucker, nor gypsy,
yet the road has a song of Her own,
an irresistible Siren in every shade of grass,
every barn silhouette, every arch of oak. . . .

She called me here, where Texas declared independence,
filling my truck with roses, my camera with cattle. . . .
Here, where side roads lurk like lust,
my map curls, soft and wrinkled as an old love;

And my Muse calls again, from just over the next ridge,
in a voice clear as moonlight:
Come . . . come . . . there's something you should see,
someone you should meet,
some story to be told . . .
each EXIT, her sultry command.

karla k. morton

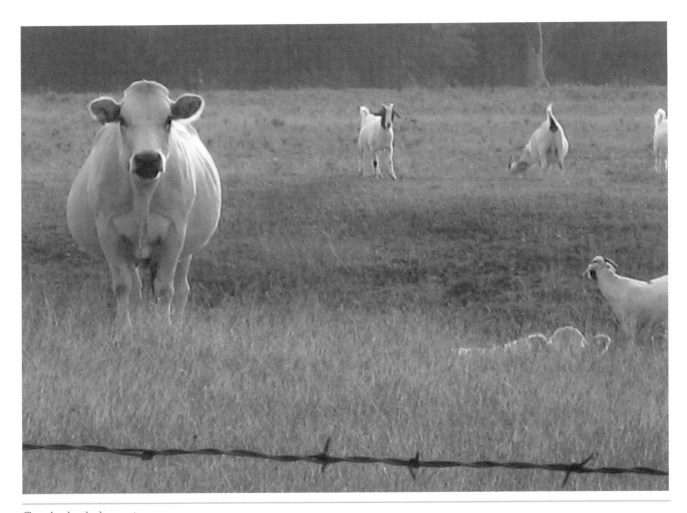

Cow by karla k. morton

ARLINGTON, TEXAS

This I Call Home

Arlington

Four Seasons

Sunny Sky

Home

Mustang Grapes

This I Call Home

The morning rings of church bells,
The *Bhajan* chants in Hindu temples,
The call to prayer Muslims entitle *Adhan*.
Hear in Arlington, these you can.

The luscious taste of Texas steak,
The smell of enchiladas Hispanics bake,
The aroma of Italian pasta with tomato paste.
Smell in Arlington, these you taste.

The cooling lakes promoting tolerance to the heat of difference,
The warming sun giving everyone sustenance,
The breezy parks, which children of all ethnicities share.
Feel in Arlington, with these you learn to care.

O, Arlington, how you give and never ask.
No one here needs wear a mask.
Shelters, apartments, houses, even domes.
Live in Arlington, this I call home.

Mostafa Salem
Lamar High School

Arlington

I am the man in the middle
I reside in the valley between
The two mountain metropolises
In the shadow of two great Titans
Nameless I am to the masses,
Yet my adjacent brothers
are showered in fame
I am Arlington

History on my right, entertainment to my left
But what am I?
Suburb is the word they use for me
Sub, meaning under, below
But I have so much to show!
The turbulent waters of Hurricane Harbor
The fusion of steel and physics of Six Flags
The pastime at the Ball Park
The architectural prowess of the Cowboys
Yet my name is not known
I exist as the nameless product of
The urban giants who drown out my voice
I am Arlington

Gibson Strickland
Lamar High School

Four Seasons

The wind crashes against my face
My body shivers from the crisp air.
My jacket zipped, my legs stumbling in my jeans
As I force myself to walk against the ferocious chill.

The leaves now yellowed.

The sun blazes overhead, burning my face
My body perspires in the humid air.
My hair tied back, my legs sweltering inside my pants
As I struggle to stand under the relentless heat.

The stems grow weak.

The rain pours down upon my face
My body drenched from the wet air.
My head covered with a hood, my legs racing rapidly
As I run to get out of the stormy weather.

The leaves float to the ground.

A sharp cold, a blazing heat, a perfect rain
A winter, a summer, and a spring all within a fall.
An entire year of seasons
Experienced throughout an ordinary Arlington day.

The trees sit bare.

Amber Morrison
Lamar High School

Sunny Sky

Crispy yellow-green grass moves beneath my feet.
Hot air swirls around me as I make my way through fields filled with chirping insects,
Creating such sounds that they seem to be singing a symphony to me as I skip along,
Never to look back at the path I have taken.

Enormous trees shelter me from the scorching sun's wrath,
Looking as if they have always belonged.
The bark that peels off their chocolate brown trunks seems to reveal a new insight to
the world they have long ago discovered.
Their long, swaying limbs sighing their untold secrets to the vast blue sky.

Barrels of tan hay that I have seen all my life, staring at me in every direction,
Galloping horses swiftly make their way towards me.
They speed past the confines of their night stalls,
The glorious creatures bent on reaching me.
Never do they slow as they dance around each other until finally reaching me.
Not once has fear crossed my mind, for this is something I have always known.
I smile up to them,
Reaching up to offer my praise,
Something which these magnificent animals will never tire of.

Tilting my face towards the sun's beautiful warmth,
I close my eyes and take a deep breath,
For I am home,
The only place I will always belong,
Arlington.

Aylin Saglik
Lamar High School

Home by Courtney Tran
Lamar High School

Mustang Grapes

Deep in July, she'd gather
five gallon buckets of purple gems
from along barbed wires—

cradling those vines as if they
were Grandmother's inheritance
passed down the family line.

A little taming of the earth—to pluck
and gather and mash and boil and sugar,
then scoop like melted jewels

into Mason jars.
Frigid January mornings,
heads still full of sleep,

we'd wake to Mom's coffee pot;
to the rush of schooldays,
a vitamin at each plate;

to toast, wet with butter,
and Grandma's Mustang jelly,
lid off at the kitchen table—

waiting like summer;
silver-spooned mouthfuls
of all things sweet and wild.

karla k. morton

JUSTIN, TEXAS

Haslet

Boot and Skull

Justin, Texas

New Icaria

Haslet

There had been a man, hard-headed and
Proud,
Who was asked to run a railroad through his land
But always turned them down.
Until one day he gave in,
And so the city of Haslet began.

Today cars file down roads,
While horses still roam in yards.
It is odd how this little town has grown,
Like a plant that has taken in the bright sun.
The railroad still lingers,
And it runs,
And runs.

Runs for miles.
Winding under the bridge,
Its cars like beads passing through trees,
That hover over in ridges,
Perching birds make it look like an aisle.
You can see small shops packed and full,
Along the road.
It doesn't look the same to me anymore,
But I love it still.

Though I do love this place,
I doubt I can stay,
When the traffic starts to pull me away.
But I will return to the place I was raised,
And feel the warm summer sun on my face,
Because even when it has changed
In my heart I'll know it's the same.
And I'll never forget the day
Haslet was named.

Brittany Moore
Northwest High School

Boot and Skull by Lyndsey Lepore
Northwest High School

Justin, Texas

Eleven years in a house that looked like it was made out of Lincoln Logs.
Blue Angel jets using the green roof as a turning point,
Putting on shows in the crisp October sky just above where we lived.

Far enough out to shoot off our own fireworks,
Too far still for outsiders to know where we were,
But just close enough to the racetrack we could hear roaring from our house.

Eleven years sitting on a homemade porch listening to the announcer in the distance,
Telling us the score of the current high school football game,
And the stadium lights the only thing breaking the country darkness.

Fifteen minutes from major dining and civilization.
Grocery stores and thrift shops in walking distance,
And an entire store dedicated to boots named after the town we were in.

Eleven years in a place where installing stoplights was a big deal,
Where stray animals were a common occurrence,
And where everyone knew each other by their last names.

Schools filling with the same kids they've known since kindergarten.
The ride home on the bus unchanging in those eleven years,
Always knowing the future teacher they were going to have.

Eleven years in a town that offered nothing but open fields,
Weeds growing to my knees in the two acres around my house,
And endless daylight hours available for playing pretend.

The sky got dark enough for storms to illuminate the whole house,
Shake the carpet as we skittishly run to our father's room,
And make our sleepy eyes wide, waiting for the sun.

Eleven years in a slowed-down pace.
The only fast things were trains chugging down the rails,
And the cars that were in a hurry to leave.

I wish I had never left that town.
Memories of those eleven years constantly playing in my head,
Wanting to return to the Lincoln Log house, far away from all that troubles me now.

Kieryn McLeod
Northwest High School

New Icaria

In theory, the idea sounded perfect—
every person living and working
to their highest potential,

each one giving to one pot; one socialist society.
"All people need," wrote Etienne Cabet, "is a perfect
environment to reach a perfect community."

He had been in France, heard old man Peters talking
about his colony in Texas, a land ripe with beasts
and fertile soil and hungry people.

So, he purchased a 10,000-acre tract from Peters's Land Company,
a land grant of their own on the edge of Denton County,
then sectioned it off to settlers . . .

but after one year, he succumbed to defeat.
New Icaria was abandoned.
The railroad came through later, settlers even naming

the town after the chief engineer, Justin Sherman . . .
But in his defense, Cabet's philosophy was only
a *little* off—for how could he realize

perfection, to a Texan,
isn't the absence of our flaws,
but our embrace of them.

And nothing in Cabet's world
could have ever prepared him
for a land so hard-fisted and wild;

or for a people as tough as Texas bulls—
no philosophy could tame;
no Frenchman could *ever* ride.

———————

karla k. morton

ROUND ROCK, TEXAS

Just Someone

A New Voyage

Golden Glass

Always Trying

Silence

I Refuse

Love Song in Bertram

Just Someone

They say once you are something,
You may never be nothing.

They say once you are nothing,
You will never be anything.

But what they don't know, is everything can come from nothing, and anything
will sprout from something.

They do not expect you to question anything they tell you, but merely agree and
let them dictate you.

They say once you become what you want to be,
You live there forever like life on a peak.

They say once you are what you've become, you can't go back to being none.

But what they don't know,
Is you are just one. Someone.

Anna Hernandez
Round Rock Opportunity Center

A New Voyage by Joshua Young
Round Rock Opportunity Center

Golden Glass

Their life collapses like so many buildings

Destroyed all they have gained

Leaving them hopeless and vulnerable to the vipers around them

The earth shakes as I stride into a once great and beautiful city

The vipers hiss and spit at me to drive me away

But I am clad in the armor of purpose

They are water as I am hot steel

So I stride unafraid to the aid of a fallen friend

I force them to their feet or

I carry them to my house of golden glass

Stephen Baker
Round Rock Opportunity Center

Always Trying

My mother's always crying
My father's always lying
me myself i'm trying
so hard to do right
and connect with god
These days are bright
but in my eyes they're
dark without light
I awake at night with
thoughts racing through
my head yelling and screaming
telling me i've got to get
ahead you can't fall behind
I've got to get mine
My mother's always crying
My father's always lying
Me myself i'm trying

Joseph Acuna
Round Rock Opportunity Center

Silence

Silence.
A discrete and ninja-like form.
A weapon of no sound.
Takes you into another world,
Imagining and believing
That you're the only one around.

Silence.
A song of peace
Soft as the clouds
But rough as ashy knuckles
And as deadly as a snake's strike.

Silence.
As calm as the wind blows,
But loud as a thunderstorm
When the power is cut.

Silence.
The sound after the hammer hitting the table
At my dad's sentencing.

Silence.

Ira Miller
Round Rock Opportunity Center

I Refuse

Devil, get up off me.
I could never go down that road.
If I was to follow you,
Then I would be walking to my own self-destruct button.
Naw, I good.
I think I'll head down the path to righteousness.
Where people live life and have a good time always.
This road is smooth and clean
So I can see where I'm steppin'.
Your road has grass growing everywhere.
I wouldn't know if there was a snake 'bout to strike.
You wanna take me under,
But I refuse to fall for it.
Naw.
I will fight the big one
Until the fight is won.
Or my casket drops.

Darrian Bryant
Round Rock Opportunity Center

Love Song in Bertram

- For Dewayne and JoAnn Nash

This is the heaven on earth God intended—
pale, stone walls; a cold
tin roof, and a hearth that burns all winter long.
To drink from the sky;

to eat from the coop—pulling oval jewels
from warm sleeping hens.
Dogs, like Vatican guards, sentry the doorways.
And when we lie down

together, coyotes croon with the shooting
stars; scorpions dance in and out of our shoes.

karla k. morton

GRANBURY, TEXAS

The Usual

Home: Where God Planted Me

Here We Search Through and Through

From the Vines

The Usual

Rawwr . . . is the first thing I say
When I wake up, to a new day.
Gotta make my bed, fix it all straight,
Get to breakfast, can't be late.
Clean my room, do my chore,
Dust my desk, sweep my floor.
Now for school, my favorite part,
I go to Bible, then to art.
Next is English, it's a little crazy,
We learn a lot, but we're all so lazy.
Let's go to lunch, eat some food,
When I'm full, it lifts my mood.
After that, I've got science,
Then it's history, with wars of defiance.
Now to numbers, which confuse my eyes,
Then on the bus, to exercise.
I play basketball, it's a fun sport,
I'm not so great, because I'm short.
Back to the unit which I live in,
I'm quite terrible, but still forgiven.
Time for dinner, let's go eat,
Then lie on the couch and rest my feet.
By then, my day is at an end,
Into my bed, there I descend.
Grab my pillow, turn off the light,
My day is over, now Goodnight.

Austin Madden
Happy Hill Farm Academy

Home: Where God Planted Me

The tides bring in new people and life along with the new school year
Heartfelt tears are shed as they leave come spring
In this land, however, some stay for years
Sumptuous trees who have seen many things

Intensified and grown much, and when their time goes, leave with hearts
 tipping at full
Subtly, I am like a lone tree in the middle of these hilly pastures

My branches spread wide from being left long to grow high
Young in comparison to this green ocean, characterized by gravel wrinkles

Held in by white fence beaches
Oh, how this could be nothing less of home
Marvelously at every break of night, God peeks out from behind His purple,
 orange, and yellow painting
Eagerly reaching down His mighty hands and blowing about my leaves and
 heart, letting me know I am safe here now, at home.

Jessica Bates
Happy Hill Farm Academy

Here We Search by Kristi Narvaez
Happy Hill Farm Academy

From the Vines

Winters on Grandpa's catfish farm,
my brother and I, casting lines,
anchoring poles, then flinging

ourselves over the crest of the bank,
the south slope, a perfect shelter
from icepick winds;

sighing as the sun would sink in
our faces; creep down through our jeans,
thinking this must be how it feels

in the womb—warm and tended,
every color of the universe shining
down upon us; two radiating bodies

at the end of a rainbow . . .
And the sun, that glorious sun,
laying hands upon us, promising

Mustang grapes to sing and jelly
for our biscuits; swelling melons
to machete all summer long.

karla k. morton

HARDIN, TEXAS

Dreams

Pencil Farm

Poet Laureate Boots

What Boots Were Made For

Dreams

Can be as big as a rainbow,
Or as small as a pot of gold,

Dreams can be fulfilled in
A second,
A minute,
An hour,
A day.

Dreams are like a highway,
So long and far away,
They seem to disappear,
But yet they are so clear.

Some days your dreams will hang low,
And others will really show,
What are dreams really all about?
Well, that is for you to find out,
So peace out!

Regan Wilson
Hardin High School

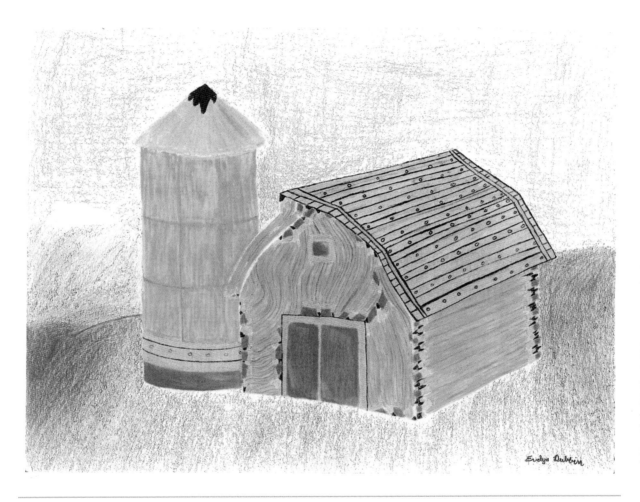

Pencil Farm by Evelyn Dubbin
Hardin High School

What Boots Were Made For

Only two weeks old, I'd worn
them to parties, showing them
off at restaurants and church, grinding the soles
into Stockyard

bricks just as soon as I stepped
outside Leddy's Custom Boots.
But this is what they were made for—borrowed
tools for the thick

Hardin peat; digging a grave
beside the road, my brand new
muddied boots coaxing the rusted shovel
deeper; deeper.

I held that owl in my arms,
her legs, thick as ginger root,
feathers soft as white tulips, her wide head
over my hand.

Beside a tall pine, I laid
her down, away from her nest
and the eyes of the street, my foot, tamping
the wet mud grave;

removing the light; sending
her back to obscurity;
back to her home—to the silence, to the
dark . . . to the night.

karla k. morton

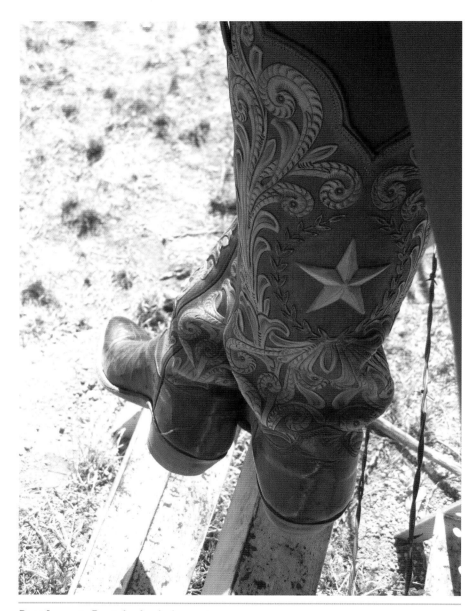

Poet Laurete Boots by karla k. morton

SALADO, TEXAS

A New Beginning

As I went outside I began to cry
To see the dog that was once by my side.
As I sat there I began to sigh
Because I knew it was time he died.
As the days passed
I never cried
Because it all happened too fast.

I lied

to myself saying that I don't care,
But the truth is, I cared too much
So I didn't want to share
My life with anyone I could touch.
But that all changed when the new dog walked in
I felt a new beginning again.

Madison Kelley
Salado High School

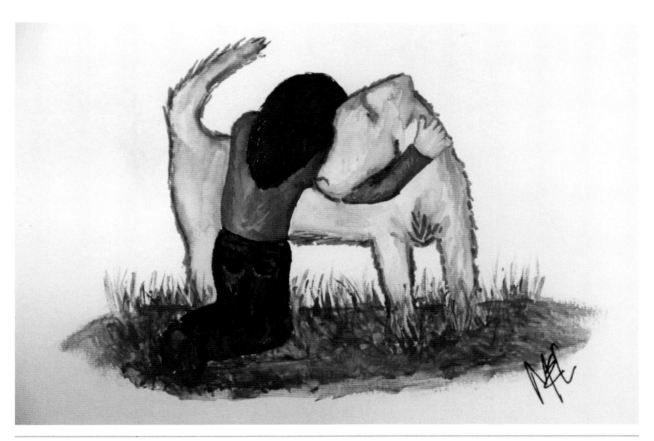

Girl and Dog by Margaret E. Cook
Salado High School

My Pets

<div align="center">

Lola
Reclusive, Skittish,
Climbing, Hiding, Meowing,
Mouse Chasing—Treat Enjoying,
Playing, Sleeping, Barking,
Friendly, Energetic
Zeke

</div>

Karson Moerbe
Salado High School

Bluebonnet by Morgan VanWinkle
Salado High School

"Where *Is* My Beautiful Beast"
— *Beauty and the Beast*

The youngest of three—Pinky, Winky, and Nod,
Nod was the tiniest of goats; the runt,
taking to his Master with a love
unrivaled between creatures.

He followed him day and night,
becoming housebroken,
his good manners gaining entry
to every party, donning a bow.

Each morning, they would visit the old
front oak, his Master tearing off a limb for him. . . .
But one day, Nod snuck into the pig feed,
and the little goat that could eat anything

would die of corn. . . .
And he carried Nod out, laying him deep
beneath his favorite oak tree,
mounds of limestone covering the grave. . . .

She told me the story with tears in her eyes—
how her husband still mourns;
saying how foolish it must seem to others
to love such a creature.

And I thought of Botticelli's *Pallas and the Centaur*
in the Uffizi, in Italy. For an hour I sat, watching
Pallas, a *goddess*; the daughter of Apollo,
reaching out to the Centaur—that massive being

with horse hooves and a man's torso;
and cried as I felt the greatest of love stories—
the glorious beauty of every beast on God's earth,
and the wide-hearted souls that love them.

- For Mrs. Jane and Darrell Voigt

karla k. morton

LAREDO, TEXAS

Forgive and Forget

Forgiving is forgetting
But what happens if I don't want to forget
I wonder if this choice I make
Will be something I'll regret

I grapple with feelings, I struggle for words
My emotions are just as tangled as all of your lies
I wonder if trusting you again
Will become my own demise

You stand there so motionless waiting for a reply
But I wonder what it is you want me to justify
After a while, I seem to drown in your eyes
Coming to a sad realization it might be time to say our goodbyes

As you follow your path
And I follow mine
Our futures I hope
Will one day again intertwine

Edna O. Garcia
United High School

When we were born, WE WERE BROWN,
When we get sick, WE ARE BROWN,
When we get sunburned, WE ARE STILL BROWN!

And sorry to say this,
but I am

When you were born, you were purple,
When you get sick, you turn blue,
When you get sunburned, you turn pink. . . .

Huh! Well, I'm going to leave you here,
but just don't think ur the best,
because you ain't

WE ARE THE BEST
PROUD TO HAVE RED, WHITE, AND GREEN IN MY VEINS
PROUD TO BE A MEXICAN!

Eric Aleman
LBJ High School

Portraits in Blue by Victor Layton
Alexander High School

The Flame

Steady is the flame that pierces the darkness
Warm words that kindle adoring feelings, joyous emotions flaring up,
shedding light to a world undiscovered

It beckons us, this flame, coursing through the dark labyrinth of insecurity

Anchoring us to our perceived reality:
A beacon
Gossip fans the flames, its fiery tendrils fluctuating, spreading
destruction in its wake, fears revisited

Another name tarnished, another reputation marred
Years of building a name crumple down in a charred, sullied heap
like the words that roll off your tongue

Once the flame is expelled, it cannot be retrieved

Alyssa Izquierdo
Alexander High School

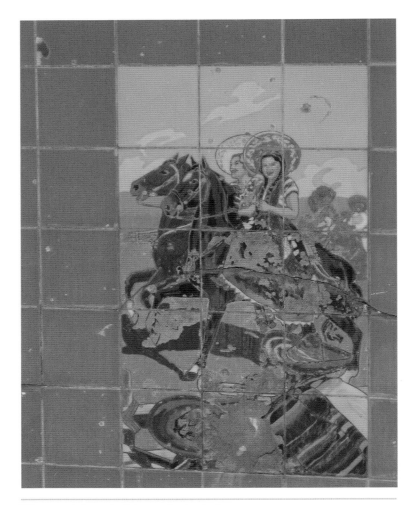

Tile mural, Laredo Library by karla k. morton

Beginning, Middle, Love

It only took a word
To ignite this spark
Which soon became a flame
Entering the realm of conversation

The conversation multiplied
And the seed began to grow
Gripping its roots
Into what became a bud

The sands of time took their toll
The flame flickered
And the blossom withered
Leaving vague imprints where they were

No ordinary imprints
Left in two hearts
Something untouchable
Love

Jesse Eash
United High School

An Ongoing Nightmare

You are in the middle of an amazing dream
Rrrring! Rrrring! Rrrring!
You are rudely awakened by your dreaded alarm clock
The alarm clock stood no chance to your fist tapping it shut
Sleepily, you try to muster the energy to get ready for school

You walk like a zombie trying to look alive
You do your best to open your eyes
Manage to get all your gear together for school
Your mind is lining up dreams against a wall
Getting ready for when you happen to fall asleep during class

After what seems like an eternity
The giant yellow bus arrives at your corner
Many colorful trees and plants zoom by
Adding to the commotion in your fuzzy mind

You are perplexed by the various colors
You have no idea what is going on around you
Abruptly, your daydream is interrupted by a faint tap
It is your best friend saying, "We're here, no time to nap."

Still in a stupor, walk into school and find your friends
Recalling everything you saw on the joyful ride
All you can really hear is *blah, blah, blah. . . .*
You follow the crowd into the nightmare class

Nervously, you take a snail's step inside and have an awkward feeling
A feeling that it is going to be an amazing day
Which never occurs regardless of how hard you try
You eye the person next to you and cautiously sit at your desk

As the day wears on
You go through the usual boring routine
Anxiously anticipating the end of the day
You drown the voices and listen to the tick tock of the clock

Finally, the moment you have been longing for
The last class of the day and you will finally be home
Your luck—this happens to take the longest
Sitting, head drooping, waiting for the bell to rescue you

An hour and half slowly ticks by
You stare at the clock for the last few seconds
The longest seconds of your life
Rrrring!!! The last bell of the day
You storm out of the class escaping the day that was

Too caught up in the excitement
You regroup with your pals and look for your bus in the blazing sun
You find it, clamber in and sink into your seat
The bus heads off to infinity
into those dreams you carefully lined up earlier

The entire ride seems to cradle you
Finally, after an hour on the bus, you're home
You walk into your familiar room and jump into bed
As you drift off to sleep, you reach a horrible thought
You have to repeat this torture tomorrow

Anthony Gonzalez
United High School

Fox by Angelica R. Martinez
Alexander High School

Nights in My Room

Silence
is the only sound heard
as I sit up in my bed.

The house is still,
Everyone is asleep
except for my thinking head.

Dreams and nightmares
engulf my mind
without even the closing of my eyes.

I cannot linger off
into that other world
with this blur still in my mind.

I am alone,
yet not lonely,
and, in fact, I am happy.

No other moment
is better than now
to speak to Him who is almighty.

This is the time
when the books are read
and when my worries are soothed.

These are my nights spent
pondering, reading, praying
alone in my little room.

Tirza Guerra
United High School

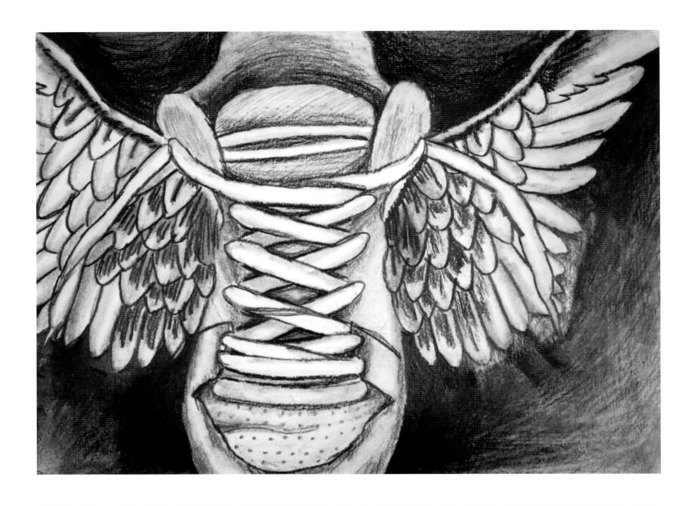

Flying Sneakers by Josue Rivera
Alexander High School

A Day of Vegetarianism

My last night in Laredo, a clairvoyant
told me I would kill a creature on the road;
said I *had* to hit it, or my truck would roll;

I had to grip the steering wheel with both hands,
and power through. . . . And I thought about myself,
one of thirteen billion people on this earth;

thought about all the animals I alone
had killed with fashion, with diet, with driving;
and vowed I would become, for just one day,

a vegetarian. I would take no life.
I caught a spider, and released it outside;
had tortillas and eggs for breakfast, veggie

soup for lunch; pasta for supper. And on my
way home, I drove slowly, held the wheel hard, kept
a careful eye on the edge of the forest.

Pleased with myself, I pulled into the drive, walked
to the house, and looked back at my truck—at the
tiny, brown sparrow embedded in the grill.

karla k. morton

BASTROP, TEXAS

Small Town Bastrop

The Colorado River Bridge

Porch Dogs

In Need of Cleansing

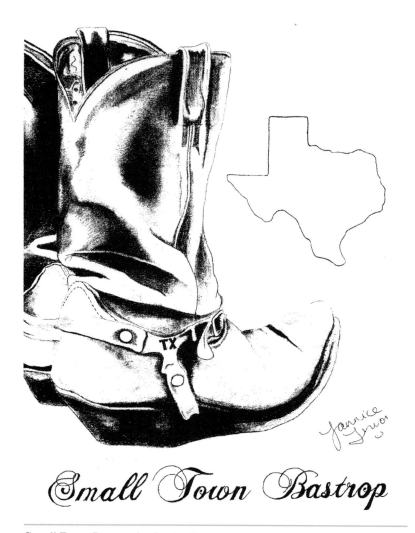

Small Town Bastrop

Small Town Bastrop by Janice Truong
Bastrop High School

The Colorado River Bridge

Three white trusses,
Big beautiful arches,
It's been there for years,
Longer than you know.

A remarkable sight
Makes you feel at ease
As you look down on
The Colorado River.

Its nostalgic charm
Overcomes you
As you approach downtown.

There are only a few left
Of these magnificent
Pieces of architecture,
So we appreciate it.
We adore it.
We commemorate it.

The bridge,
The majesty,
Our own part of history.

Lilly Burson
Bastrop High School

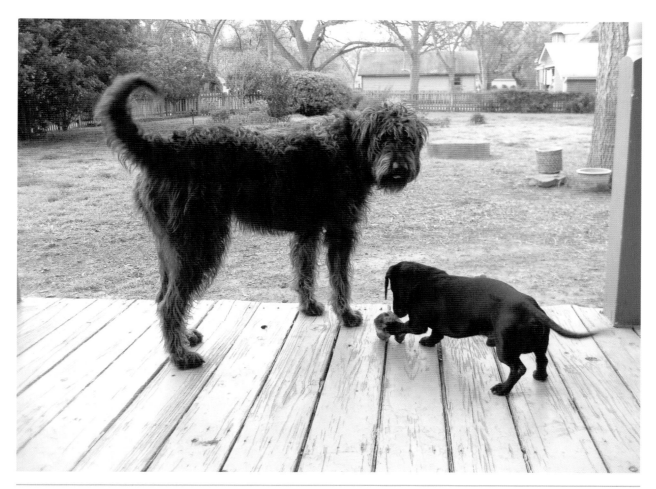

Porch Dogs by karla k. morton

In Need of Cleansing

"Septic Tanks for Jesus"—Bastrop, Texas

It was a new way of seeing. . . .
Years in the business,
he became accustomed to inspection—
couldn't help it really—
septic tanks hold everyone's secrets.

He knew by the pink chemical reaction,
his client was on blood pressure medicine,
but this was a different shade,
a darker, more dangerous shade:
chemotherapy made its own hue.

He dropped the hose, ran into the house,
laid his hands upon the man, and began praying—
right there at the kitchen table,
awkwardly bypassing the doorbell,
the sink, and the soap.

karla k. morton

MARFA, TEXAS

Football
Lovely Shade
Pen
Big Bend Left Tree
Making Peace with Scorpions

Football

It's the best feeling when you run the ball
Sometimes you get hit, you take a fall

It gives you an adrenaline rush with no yield
There's nothing better in the world than being on the field

When you hit someone it's not very nice
But it's what's fun and they gotta pay the price

If you're good you'll score a touchdown
It takes heart you'll never go down

Football's something you'll love
It's something you'll cherish forever and above

Rene Granado
Marfa Junior/Senior High School

Lovely Shade

Love, how tall you are,
Love, you shade me from the sun,
No complaining, no.

I lean against you,
Love, the wind blows, and you sing,
Love, you bow so low.

You and I, we are
Very different you see,
Love, your clothes fall off.

Love, friendly with birds,
That's you, love, you wrap their nests,
Songs sing me to sleep.

Yet you are so rough,
As I lean against you, love,
Love, my lovely shade.

Eileen Cordova
Marfa Junior/Senior High School

Pen

When I hold you in my hand,
I can express who I am.

Following your traces,
No matter what races,
Everyone can enter the world that one faces.

Because of your stories,
I get to know the histories,
With great civilizations and unknown mysteries.

Sitting by the table I read my diaries,
I know you note down all my best memories,
Including childhood happiness and exciting victories.

When I hold you in my hand,
You can understand who I am.

———————

Kimi Si
Marfa Junior/Senior High School

Into Big Bend by karla k. morton

Making Peace with Scorpions

I learned they *always* travel in pairs;
they mate for life.

And when one walked across my path,
dozens of babies high on her back,

one fell off, and she stopped
and turned—her long, venomous tail

gently scooping it up, tucking it back
on its perch . . . my heart clicked open.

That night, I dreamed of a scorpion
with an *ohm* shaped tail; and the next day,

as we walked together, shadow to shadow,
on top of those Marfa mountains,

marveling at the endless view, and the millions
of chalcedony and agate at our feet,

I wondered how I ever could have cursed
a creature with that much God in its eyes.

karla k. morton

EULESS, TEXAS

More Than a Word

Street Scene

My Hula-Hoop Girl

Owls

More Than a Word

Home.
Four letters could never mean so much.
Home is the place where the memories of overhead planes,
Dusty construction sites,
And warm evenings on the patio with loved ones beside.
Where summer days are boiling hot,
And the evenings are like a warm blanket,
Wrapping around your shoulders as you soak in the last minutes of the day.

Home.
Where the memories of evening swims evoke emotions of innocence and love,
The memories so strong that you can still hear the locusts buzzing in the trees,
Shedding their pasts while you were making yours.
Where your breath froze in your throat despite the heat
Because he returned your puppy-love gaze,
At the end of the lane, where the line between White and Red Oak blurred to pink.
Just like the color of your young cheeks.

Home.
Where spring and autumn pass quickly,
And winter is nothing but chalkboards and tests.
Where Christmastime is always cold and bleak, without any snow.
Where you got a new bike from Santa, instead of a sled.
Where winter is being huddled around a lit fireplace
And summer is in the pool, hiding from the blistering sun.

Home.
Where years pass by in a blink,
And days never seem to end.
No four letters could ever mean so much.

Mary Williams
Trinity High School

Street Scene by Amjad Siddig
Trinity High School

My Hula-Hoop Girl

Isn't it fantastic?
The cold and the blue
and the way the wind blows
through the heathers and
the feathers in your hair?

You're my hula-hoop girl
spinning me around the way your hips turn.
Clockwork smile
graceful like a spider
closing your eyes and dancing to the beat of my song.

Isn't it fantastic?
The warm and the blue
in your eyes and the skies
and your tender fingers.
The feathers in your hair.

You're my hula-hoop girl
spinning me around the way your hips turn.
Clockwork smile
graceful like a spider
closing your eyes and dancing to the beat of my song.

Sasha Gillam
Trinity High School

Owls

At dawn, owls fly back to moss nests,
their last wee beast, a late-night drink,
watching that golden orb rise east,
then time to rest. . . .

To close their eyes, and sink to sleep,
counting the tiny field mice songs;
dreaming of a darkness as wide
as it is deep,

and of a twilight, cool and long.
But come their dawn of rising moon,
the scuttling of hairy feet—
their treasured tune.

karla k. morton

KRUM, TEXAS

Horse

Windmill

Danny Keough

Horse

Horses munch and nibble on pasture grasses

Oh how they love it in Krum

Ripping and romping, fun to ride

Snorting and loping, manes flowing wild

Extending their necks; heads held high.

Cristina Romo
Blanche Dodd Intermediate

Windmill by Mikayla Vilicich
Blanche Dodd Intermediate

Danny Keough

In 7th grade, it was all about
the fitting in, not the sticking out,
but the most important thing, no doubt,
was a class with Danny Keough.

And my, oh my, what a handsome lad
Who could look your way and make you glad
that a boyfriend you would never have
to compete with Danny Keough.

Now all through school, I was the girl who
made the grades but lacked the looks to twirl
a boy around her smile—not his type—
in the world of Danny Keough.

But life has its great ups and downs—
we moved away, another town,
but came back to spin just one more round—
a chance to dance with Danny Keough.

The time was right, with nothing to lose,
I asked him, "Please, would you please choose one
dance with me?" Oh . . . would he *refuse*? . . . but . . .
then he *touched* me . . . *Danny Keough*!

Now, all the girls were just bug-eyed but
fate was truly on my side, for the
next slow song was an eight-minute ride
in the arms of Danny Keough.

"Stairway to Heaven," the song that thawed
my heart to men, leaving me in awe,
that someone like him would dance with me—
Oh my God!!! with *Danny Keough*!

So let this be a lesson to all,
they may say no, or you may fall, but
before it's our last curtain call, let's
risk the world for Danny Keough.

karla k. morton

BEAUMONT, TEXAS

St. Anthony's Bascilica of Beaumont

Violette in Grey

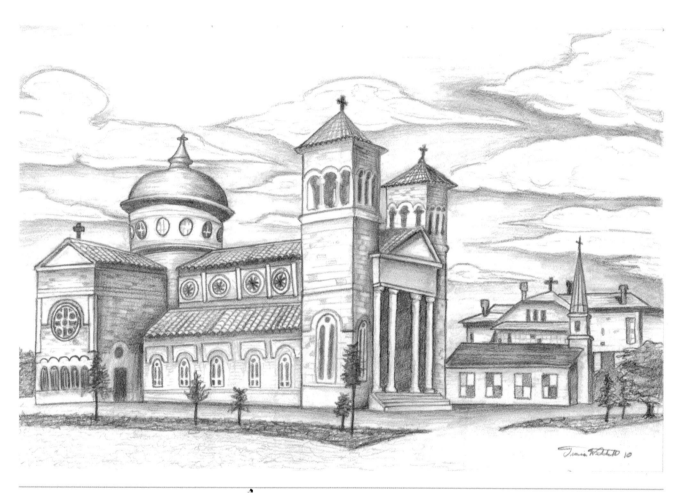

St. Anthony's Basilica of Beaumont by Travis Walthall
Monsignor Kelly Catholic High School

Violette in Gray

- for Violette Newton, 1973 Texas Poet Laureate

She said last week, she thought she would die;
talked about all the people she loved
as if they had just walked out the door.
I didn't correct her; didn't say her parents were dead;
that William Barney was dead.

I asked if the words still came. She grinned
and tapped her head, saying they were all
right there... *"sometimes you just have to go
look for them."* I imagined her traveling mind, straying
back and forth in time, as though

she were wading those Beaumont thickets,
wandering through marsh trees as wintered
as her hair; how she would search until
she found him—the love of her life—bursting through the greyness,
eyes vivid; leaning against

a flowering redbud, like a man
in waiting—arms crossed; shoulder to trunk;
one knee bent; resting. How he would smile,
and a poem would crayola across her lips—one single,
glorious, *Hallelujah*.

karla k. morton

*Texas Poet Laureate Violette Newton
passed away on February 2, 2013,
at the age of one hundred.*

BOWIE, TEXAS

Sweet Tea and Summer Heat

A soft breeze blows through pecan trees, a quiet evening in small town USA.
Nothing to do, old and used, homework due, church pew.

Friday night, football fight, bright lights.

Monday morning, mourning death, death of the weekend. Wake up and do it again.
Get out of school, go outside, hot air blisters your head, go back to bed.

Girls texting on their phones, TMI, text u l8r, LOL stands for loss of life.
So much to do outside, that's out of mind.

Skate park, play at the park, press play, day by day.

Eat out, times out, must go fast, fast food, drive thru, drive by, chicken thigh, deep fried.

Dirt roads lead to nothing, nothing is always something, something special.

Amanda Watson
Bowie Junior High

How Do You Say Boring?

I live in a nowhere town.
No one knows where it is.
Or how to pronounce the name.
If you have a secret, the whole town will figure it out.
As if there's nothing else to talk about
Except for that one thing you did or said.

Our main events are a rodeo
and Second Monday.
We shop Wal-Mart for almost everything.
It's like to a redneck, duct tape fixes all.
We have two chicken restaurants that constantly battle
Over bragging rights for the best sweet tea.

I swear, this little town
Is the only town
Where you can advertise
A carwash in the middle of our main highway.

Erika Ashley
Bowie Junior High

This Town

This is a town
where people can escape.
It's a town where you can actually come to relax.

This is a town filled with joy.
It's a town where you can roam in
fields of daisies and feel the soft touches of the petals.

This is a town where you can
wake up to the sight of the dew on the grass,
sparkling in the sun like crystals.

This is a town where you can
go to secret streams and think while
watching the birds fly.

This is a town where you can gaze at the stars
in the peaceful, quiet, and dark night
without any interruptions.

This is a town where you can leave the bad.
Start a new life. Turn your life back to normal.
This is my town.

Caitlin Butler
Bowie Junior High

Bowie Snow Globes

"Have you ever wished for an endless night,
lassoed the moon and stars and pulled that rope tight . . ."

- Pink

Maybe it was the best cup of coffee
I've had on the road,
or because the entire town took flu shots
at the Dairy Queen.

Or maybe it was all the smiling men;
or that Jupiter
was closer to earth than it's ever been;
or that my birthday

was the day before—the first cool evening
of the season—stars
sparking crisp and tight; or that the air was
intoxicating—

a mix of cedar and cattle and night.
I rolled the windows
down; the moon-roof, open, and circled rounds
in those downtown lanes—

slow figure 8's, not wanting to let go;
the old *RODEO*
limestone gates waving me homeward; each street-
lamp, a globe—aglow

in white light, spinning crickets like black snow.

karla k. morton

PORT ARANSAS, TEXAS

Chapel

Port Aransas

The Beacon of Port Aransas

Chapel by Dylan Klinger
Ancel R. Burdette Middle School

Chapel

I live in a land where the chapel
Rests silently waiting on a dune
Guarded by coyotes, snakes, and cattails
Waiting for worshippers to enter and pray.

Richard "Gus" Adams
Ancel R. Burdette Middle School

Port Aransas Chapel by karla k. morton

Port Aransas

I live in a land
Where dolphins swim
Through a salty adventure
And when they reach Atlantis
They find a home.

I live in a land
When you're on a boat
You feel the water hit your face
in a soft way.
You hear it say you have a good life.

I live in a land
Where coyotes roam the fields
To hunt for food
To survive.

I live in a land
Where water rushes up on the beach
and when you see a seashell
You take it
And say, thank you.

William Armstrong
Ancel R. Burdette Middle School

The Beacon of Port Aransas

- for Rick Pratt

He talked about that War of Northern Aggression—
how the Yankees had taken the Lighthouse,
making plans to summon their troops by sea,
but Confederate soldiers snuck through the lines,
and disabled it with their last two kegs of gunpowder—
some believing they scurried up and stole its great lens,
burying it somewhere deep in the marsh;
those years when the lighthouse went dark. . . .

As he told the story, I took a deep look at him—
the Keeper of the Lighthouse
for twenty years, living on its secluded island,
with no need for drapes, his only neighbors
the dolphins, egrets, and rising sun.

He had loved it there—only leaving when he had to—
when his right eye was blinded. . . .
And I thought how alike they both were—
his tall frame, powerful and steadfast;
one eye lost to the wounds of the past;
the other, a light we're all drawn to—
a beacon in this world of darkness and storm.

karla k. morton

MESQUITE, TEXAS

Memories of Mesquite

Small Town

Guitar

Taking the Blame

Memories of Mesquite

My mom came here in '66
My dad in '72.
Mesquite was still small,
But quickly it grew.

In the '70s two new things,
A mall and a road,
LBJ Freeway and Town East Mall
Would soon unfold.

While at Mesquite High in '75,
A new stadium to march in, soon would arrive.

Friday night football,
A stadium called Memorial
Fans of all schools
Would remain loyal.

A school planetarium
A place to see stars
Students of all ages
Would learn about Mars.

Horses and bulls
Eight seconds in the saddle,
Mesquite Rodeo was grand
Kids loved the calf scramble.

A lot has changed
Since way back then
As my parents remember it all over again.

I'm glad they stayed in this city
Where I can watch it grow.
I'll make my own memories
To tell when I am old.

Emma Flowers
Mesquite High School

Small Town

Mesquite
Mesquite, Texas
Mesquite High School
Mesquite Barbecue
The place I live
The place I sleep
The place I learn
The place I eat
The place I love
Where trees grow tall
With houses built small
and everyone knows their neighbor
where we spend our days in the sun
where in the park we have fun
and where our hard labor goes
where would I be without Mesquite

Erica Carnley
Mesquite High School

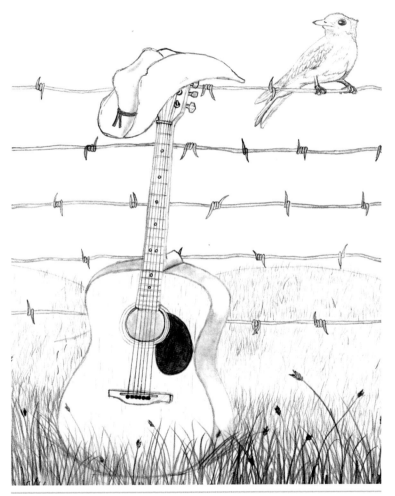

Guitar by Landon Bradshaw
Mesquite High School

Taking the Blame

Dad always had a fear of fire—keeping two
fire extinguishers
handy; strict garbage rules: one can for the dump,
one can just to burn.

Fresh in high school, my head full of phones, hairspray,
and boys, I woke one
Saturday to an explosion in the back,
running out to charred

grasses and hulking flames crawling towards our
neighbor's barn. I ran
back for the garden hose as sirens warbled,
and thick grey smoke swarmed;

the fear pasting Dad's face, becoming my own
as the monster grew;
my blown-out can of Aqua Net—an empty
bombshell at my feet.

karla k. morton

TEXARKANA, TEXAS

Abstract

A Historic Town

Straddling Texarkana

Beyond Fate and Atlanta

Abstract by Andrew Lusk
Texas High School

A Historic Town

A historic town,
With many unknown secrets
That are yet to solve.

Chau Dong
Texas High School

Straddling Texarkana by karla k. morton

Beyond Fate and Atlanta: The Town of Texarkana

He had been an addict and homeless
on the streets of California,
stars tattooed on each side of his neck—
said he was always strangely drawn to stars. . . .

Completely lost and broken,
a friend told him she'd found peace
in a little Texas town
past Fate and Atlanta;

and he had come,
three years ago this very day;
home and God
spilling from his hands
like freed doves.

This, he said,
is the place to be from,
to come and heal
where Texas bursts her seams. . . .

I stand, one boot in Texas,
the other in Arkansas,
in this place beyond
the eyes of Fate, and Atlanta;
this place of stars and doves—
this great town of Texarkana.

karla k. morton

AMARILLO, TEXAS

Amarillo: A Place in My Heart

Calling the Cattle

Sunset

Summer People

Amarillo: A Place In My Heart

Amarillo has been my home for fifteen years.
I have found it to be a place that causes me to rethink what I believe about a home.
Growing up, I thought that a home was just some place where one goes after
School or work and just sits there playing games or watching TV.

Home is none of that.

Home is where the love and compassion of a family is and where one can
escape one's troubles.
Amarillo will always stay in my heart, even after I grow up and go off to college.

The big city may have skyscrapers and big corporations, but it doesn't have
the simple beauties of Amarillo.

In the city, one can't see the stars twinkle, or a sunset set the sky aflame.
In the city, one can't see horses walking next to cars or see Cadillacs buried
in dirt at Cadillac Ranch.

In the city, one can't find a 72 oz. steak to have for free if eaten in an hour
at a Big Texan or see the Palo Duro Canyon,
second only to the Grand Canyon.

No matter what people say about my town, Amarillo will always be in my heart.
I won't remember it a boring town with nothing to do, but as a place
where I grew up, and became who I am today.

Gabriel Maliha
Amarillo High School

Calling the Cattle

We humans have a love of cattle—
with bodies thick and bells that rattle;
with skinny tails made just for whipping;
and busy mouths all wet and dripping;
and furry ears that keep on thinking
they're hearing windmills spin for drinking.

But one time when they needed drinking,
their ears were pricked—such thirsty cattle.
They heard a sound that got them thinking—
a long snort snort; a little rattle—
could this be some cool water dripping?
They looked around through winds a-whipping,

and followed close those sounds a-whipping—
could these sounds lead to cattle drinking?
And then they ran, their wide mouths dripping,
Angus, Longhorns, all breeds of cattle
who came because of all this rattle,
water was calling, they were thinking. . . .

But it *wasn't* what they were thinking. . . .
and yes, they heard some winds a-whipping,
but what, they found, in this great rattle,
was not just water for their drinking,
and in surprise to all the cattle,
was just a human, wet and dripping!

And in a tub! Her long toes dripping!
But she was sleeping, and not thinking
about her sounds, which called the cattle,
who raced to find no windmill whipping,
and more than water just for drinking,
but *snoring*, what a vicious rattle!

And oh, how loud! Those doors did rattle!
Her long toes kept the water dripping.
But those great bovines wanted drinking,
and put their boney heads to thinking
how they could move that girl by whipping
their tails—oh, mischievous cattle!

Rattle woke her. . . . "RUN!" she was thinking
and jumped out, dripping; wet hair whipping,
and left her tub for cattle, drinking.

karla k. morton

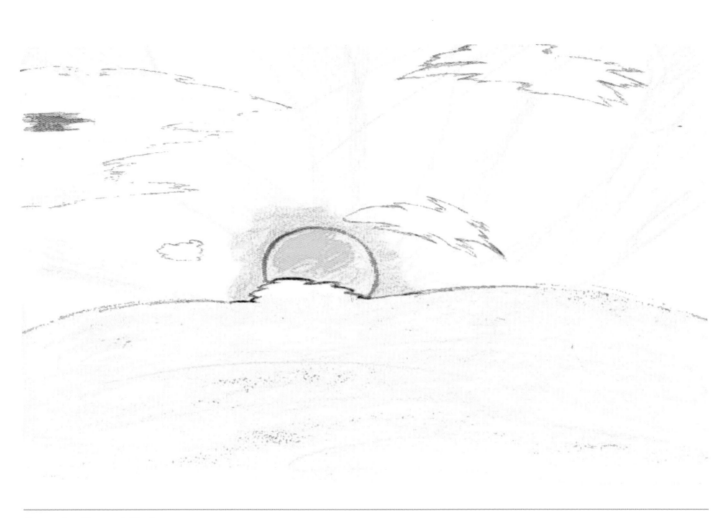

Sunset by Kennedi Taylor
Amarillo High School

- *"It was drawn at my Uncle's ranch in the Panhandle."*

Summer People

Texas in the summer,
Hot as can be.
Temperatures fluctuate,
Reaching 108 degrees.

A reflection of the people,
With their cups half full.
Enjoying the summer breeze,
Not at all dull.

Birds travel in flocks,
Having returned to what they call home.
A sense of togetherness,
As large as a dome.

Birds are people,
Moving as a group,
No one is lonely.
Everyone in a troupe.

Little town, big heart.
Always completely joined.

Amarillo.
Am a ril lo.
Amarillo.

Shan Su
Amarillo High School

COMFORT, TEXAS

One Place, One Home

Horny Toad

Alamo Meat Market

Armadillo

Comfort Sunset

Oil Rig

Hill Country Glow

Armadillos

Sweet Home

A Texas Sunset in the City

The Miniature

Sad Black Cow

Comfort and Joy

One Place, One Home

One place, one home my heart will forever rely on.
It is never to be forgotten, nor ever to be replaced.
It is full of hope and superb memories.
It is a home that can only be found in that one, tiny location.

It is a small piece of serenity stuck in the middle of the busy world.
On-looking eyes would pass it by if they overlooked the details,
But to those who are raised here, it is the foremost location they see.
It is a home, and always will be.

To some, it is the river that flows in and out of town,
To others, it is the school that has taught so many how to live,
But to all, it is the sense of comfort and peace that can be found in its name.
It is a home, and a memoir that warms many hearts.

Even if it is torn down by the growth of industries,
Even if the maps have forgotten its name,
Even if the world can't wait to surmount it,
It is a home, and it will remain forever so.

Visited daily in both the heart and the mind of its family,
Bringing joy, as well as hope to all that have the luxury of being a piece of it,
It is a memory; it is a life that cannot be forgotten.
It is a home, and forever it will reign.

Tiffany Boerner
Comfort High School

Horny Toad by De Hetherington
Comfort High School

Alamo Meat Market

Sausage—world's famous, spicy, dry, and flavor-filled
A counter filled with meat

Laughter fills the air, cheering everyone up
Some high school guys, the inspector, me,
my dad cuttin' up meat to fill the space behind the glass

Sixty-five years of gratitude, satisfaction fulfilling the customers' hearts
Closed—he had had enough of working by himself,
alone with his conscience full of thoughts

Too bad it had to end, all those sad others filled with tender feelings
Now we drive away with happiness in our hearts, full of great times

Russell Pankratz
Comfort Middle School

Armadillo by Allie Jenkins
Comfort High School

Comfort Sunset

As it sinks below the western horizon,
it sets the evening sky on fire.
The reds, pinks, yellows, and oranges all burn with fury.
At any moment it seems as if the sky
will give in to the flames.

Sara Zunker
Comfort Middle School

Oil Rig by Justin Tefs
Comfort High School

Hill Country Glow

That crazy mix of all the
Colors in the rainbow is
What this is about.

The way it catches your
Eye when you don't
Expect it is
What this is about.

The beauty of it
Bouncing off the trees
And dancing on your face is
What this is about.

The way the center is
Like the flame of a
Candle in a dark room is
What this is about.

The way it is like a
Fireworks show, it's a
Treat to see it is
What this is about.

The only sad part about
It is it only lasts for a while
And it's gone, in the blink
Of an eye,
But you still saw the
Breathtaking
Attractiveness of the wonderful
Hill Country Glow.

Delaney Petermann
Comfort Middle School

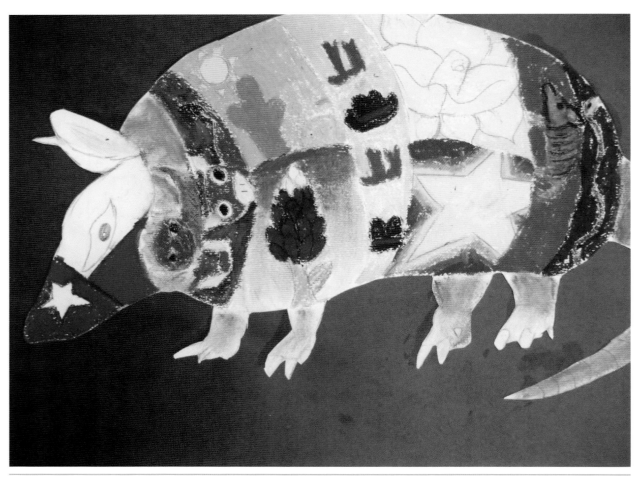

Texas Symbols Armadillo by Shelby Feldman
Comfort Middle School

Sweet Home

Where was I?

I didn't know

Lost in a world of my thoughts

Lost in a world where nothing matters

I couldn't see the light in all the darkness

Then, incredibly, I heard the beautiful birds' chirps

I heard the soft wind through the trees

And I looked to the big, blue sky

I smelled the sweet scent of fragrant flowers

Of fresh cut grass

And suddenly I knew what I hadn't before

I was home at last

Oh, home sweet home

Here in the little town of Comfort, Texas

Sophie LeBlanc
Comfort Middle School

A Texas Sunset in the City by Melissa Simental
Comfort Middle School

The Miniature

If anyone knew whether
the world is as small
as this town that is called Comfort,
would you actually believe
that anyone?
Would the cities change
and replace Wal-Mart
with a Super "S" Foods Store?
Would they replace their
bulky, greasy, Burger King burgers
for a piece of steak that's smothered in barbeque sauce?
Would they go ahead and hold
a parade for Christmas
even though people view it as "lame"?
Probably not.
But, maybe, just maybe,
they'll take a glance around at
this sleepy, antique town and
maybe even realize,
that Comfort may be small in view,
but it is big in heart.

Selma Lara
Comfort Middle School

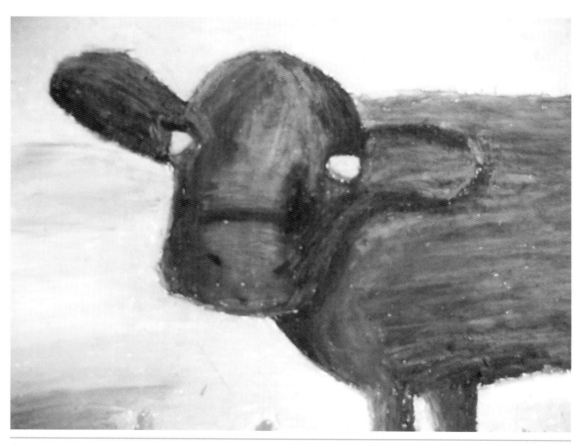

Sad Black Cow by Madeline Brown
Comfort Middle School

Comfort and Joy

The routes they took were different from mine,
major and minor rivers rushing like chords
beneath spoked wheels;
winds as steady as cello thrums;
riffs of English and Kiowa and Spanish—
welcome harmonies to ancient German staccato.

But when they rounded Fredericksburg's crescendo,
cantering twenty miles south, they must have stopped,
dropped rough-booted feet to fertile ground;
laid ears on hot creamy limestone,

and *listened* to the music of the rock—
that epiphanal silence wrapping like down around the soul—
when you close your eyes
and *finally* understand
what it means to sing the sweet song of home.

karla k. morton

DENTON, TEXAS

Picking Flowers, Tall as Towers

Secret Garden

Make it Red

Secret Garden

Down the steep rugged
rocks, through the sharp
thorns and tall weeds

I can smell the fresh red
berries leading to the
one place I can go and
just be myself.

There lies a secret garden
not too far from my house
in the middle of nowhere. I can
hear the birds chirping in the sky.

And I hear the tree branches
breaking from beneath me. This is
where I love to go where it's quiet and
peaceful. This is all real
here in Denton.

McKenna Smith
Strickland Middle School

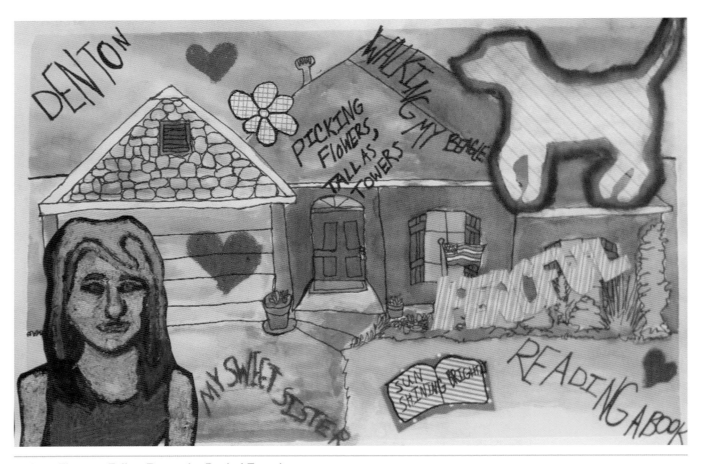

Picking Flowers, Tall as Towers by Rachel French
Strickland Middle School

Make it Red

The flight of the cardinal—
that intense flash of red
that should be the mirror of the lives
that we've led

Our days are so finite—
when we're born, 'til we're dead.
So, while on earth, be alive!
Make it glorious!
Make It Red!

karla k. morton

Score

Make It Red
for Soprano Solo, Handbells, Handchimes, and Percussion

Karla K. Morton, *2010 Texas Poet Laureate*

Carol Lynn Mizell

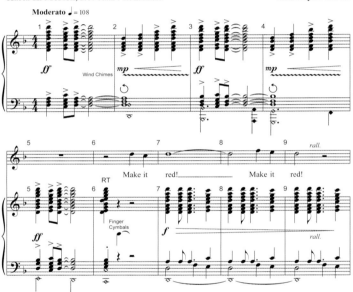

Make it Red musical score by Carol Lynn Mizell, music teacher
Strickland Middle School

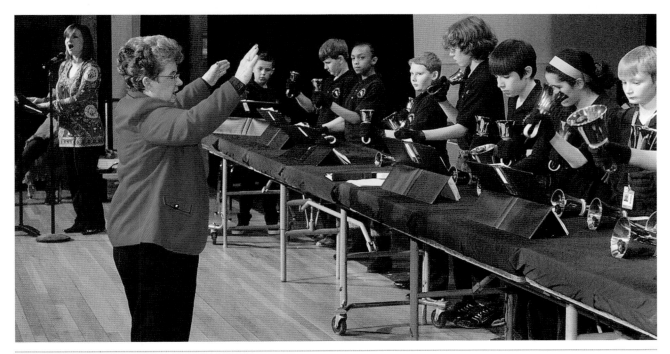

Carol Lynn Mizell and the Hand Bell Choir Photo by Al Key-Denton Record Chronicle

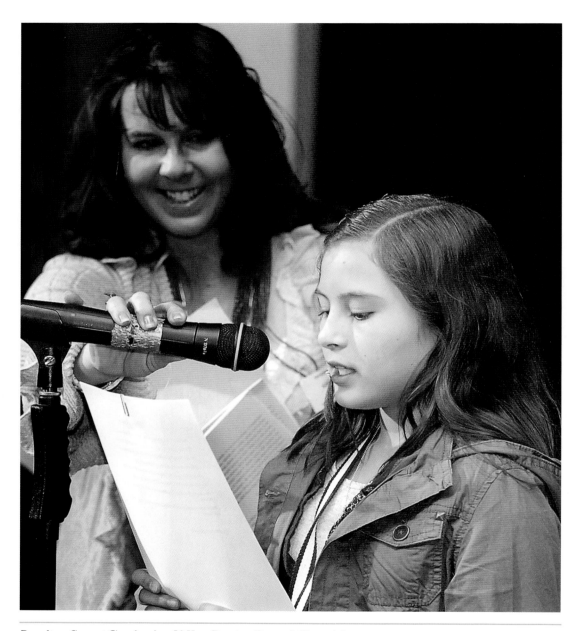

Reading Secret Garden by Al Key-Denton Record Chronicle

McKenna Smith Reading her poem "Secret Garden," with karla k. morton